Fancy
Frenchies

1 3 5 7 9 10 8 6 4 2

Pop Press, an imprint of Ebury Publishing,
20 Vauxhall Bridge Road,
London SW1V 2SA

Pop Press is part of the Penguin Random House group of companies
whose addresses can be found at global.penguinrandomhouse.com

Copyright © Pop Press 2018

For full photography copyright list see page 96.

First published by Pop Press in 2018.

www.penguin.co.uk

A CIP catalogue record for this book is available from the British Library

ISBN: 978 1 785 03855 6

Design by Ben Ottridge
Text and picture research by Abbie Headon
Printed and bound in China by Toppan Leefung

Penguin Random House is committed to a sustainable future for our business, our readers
and our planet. This book is made from Forest Stewardship Council® certified paper.

Fancy
Frenchies

Impawsably
Stylish Bulldogs

POP PRESS

BULLY

WOOD

Famous Frenchies

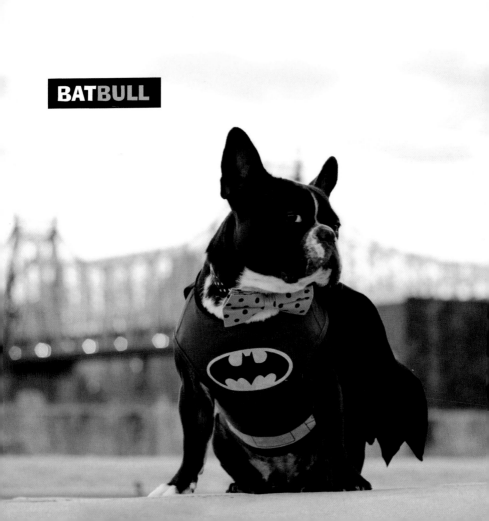

BATBULL

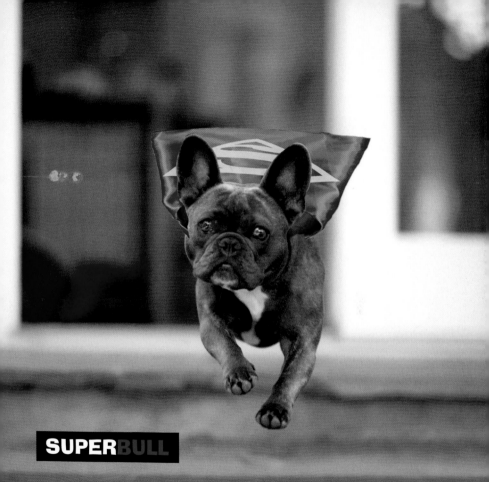

SUPER BULL

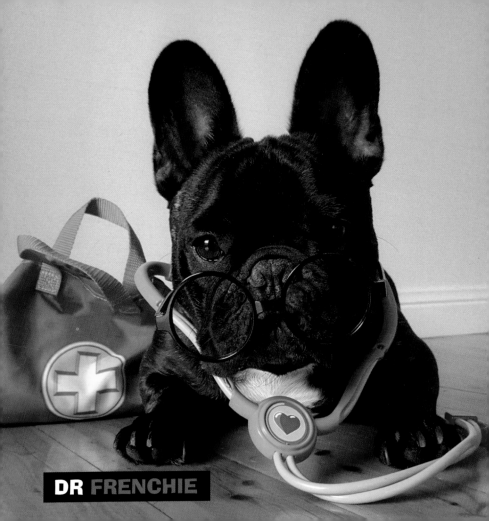

DR FRENCHIE

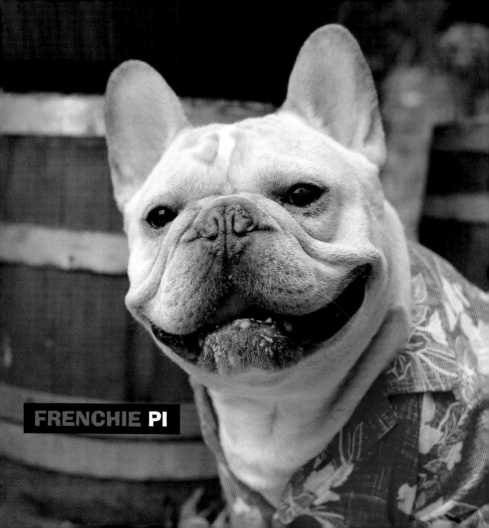

FRENCHIE PI

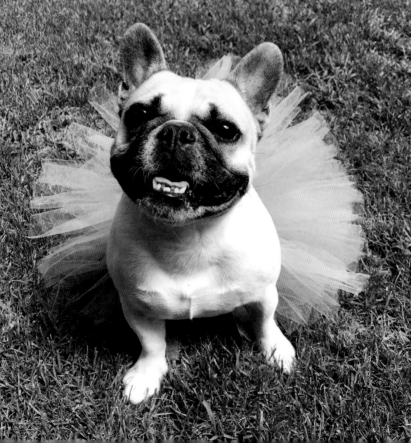

FRENCHIE FONTEYN

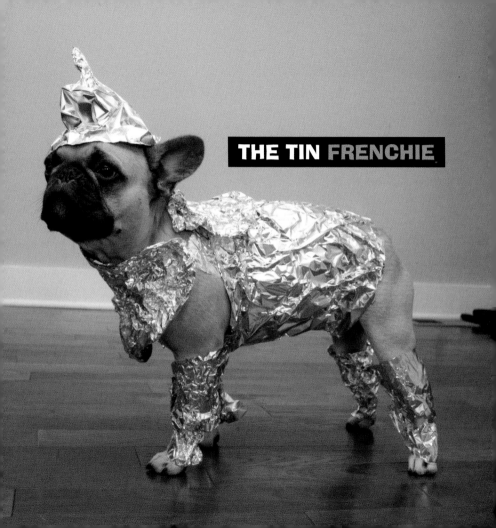

THE TIN **FRENCHIE**

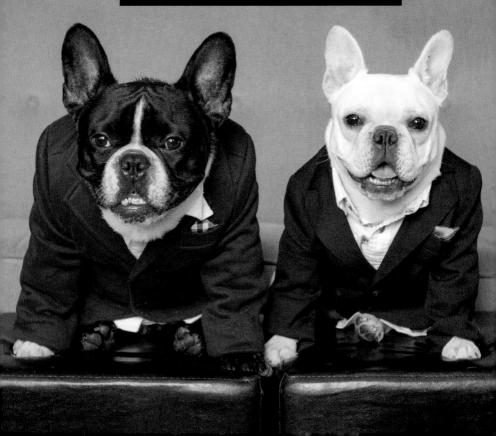

APPRENTICE FRENCHIES

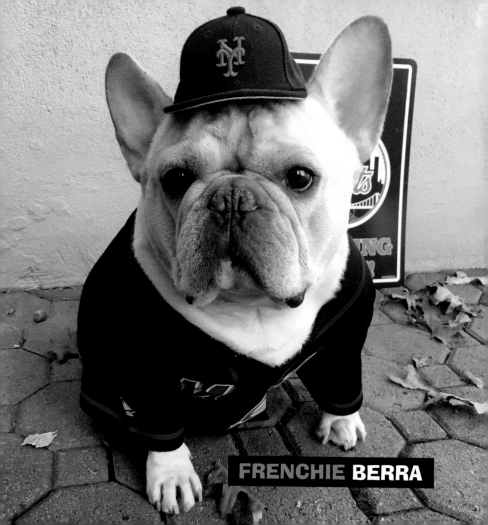

FRENCHIE **BERRA**

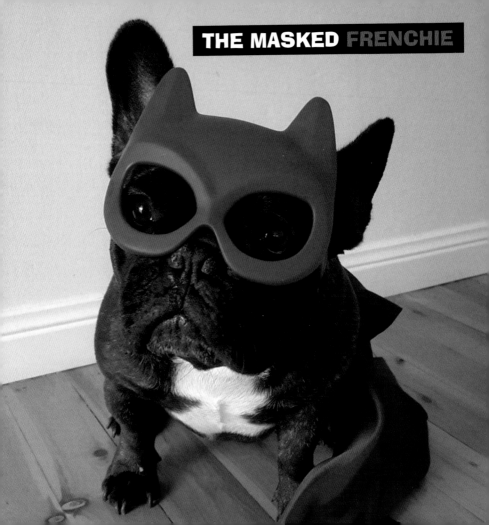

THE MASKED FRENCHIE

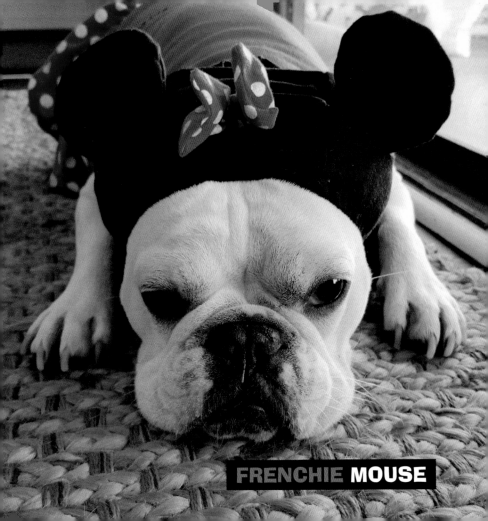

FRENCHIE **MOUSE**

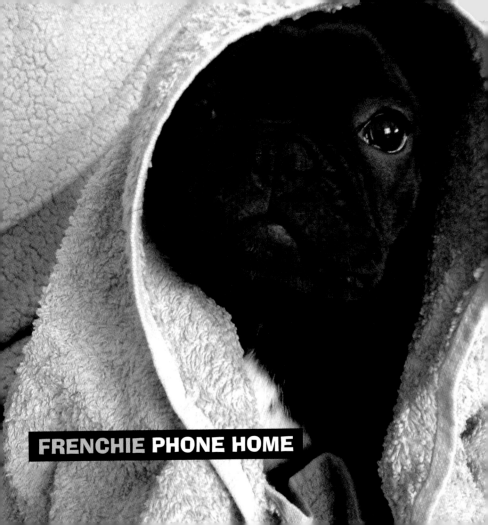

FRENCHIE **PHONE HOME**

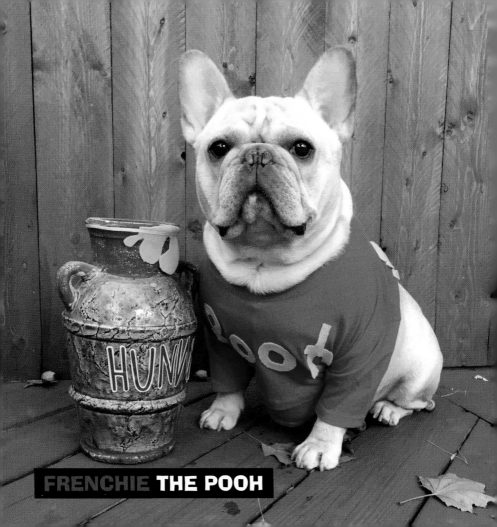

FRENCHIE **THE POOH**

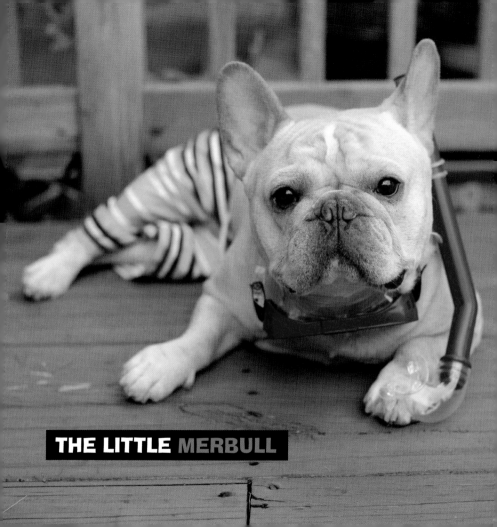

THE LITTLE MERBULL

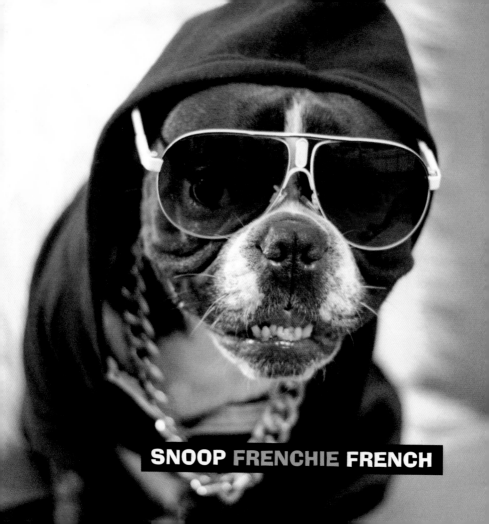

SNOOP FRENCHIE FRENCH

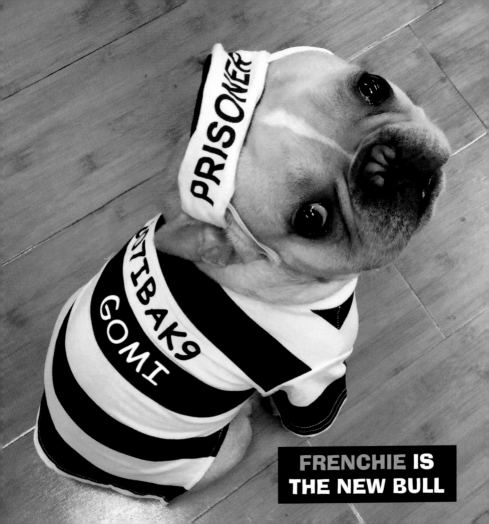

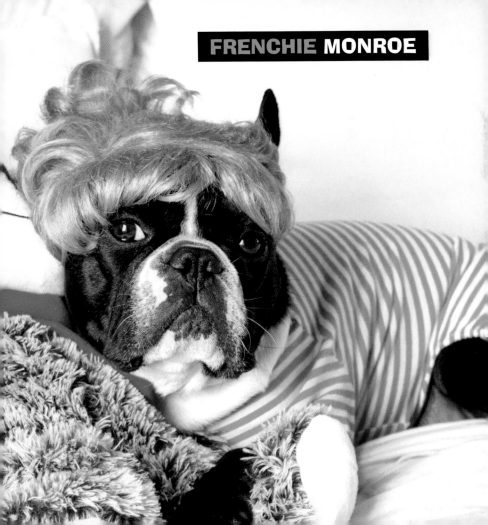

FRENCHIE **MONROE**

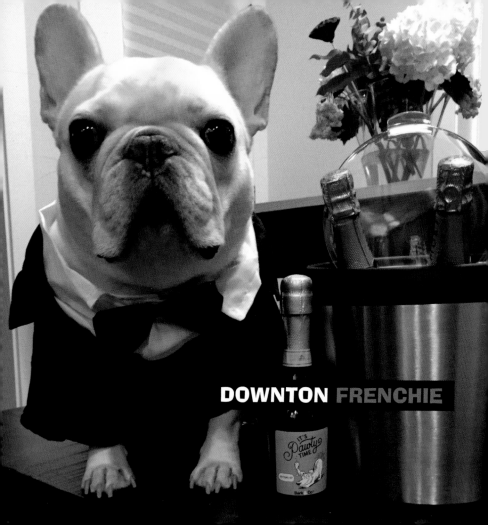

DOWNTON FRENCHIE

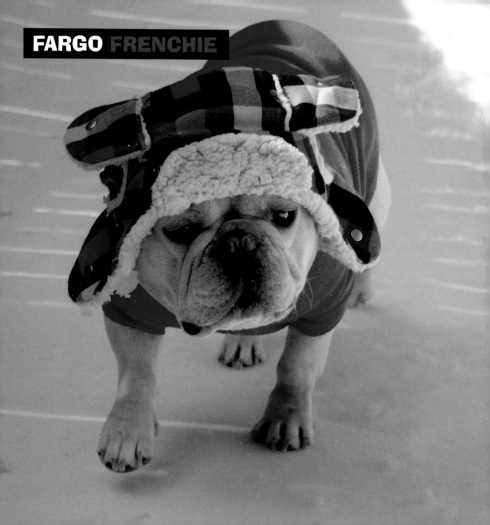

FARGO FRENCHIE

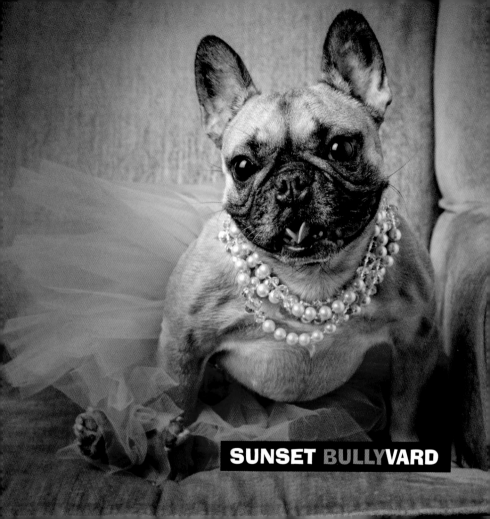

SUNSET BULLYVARD

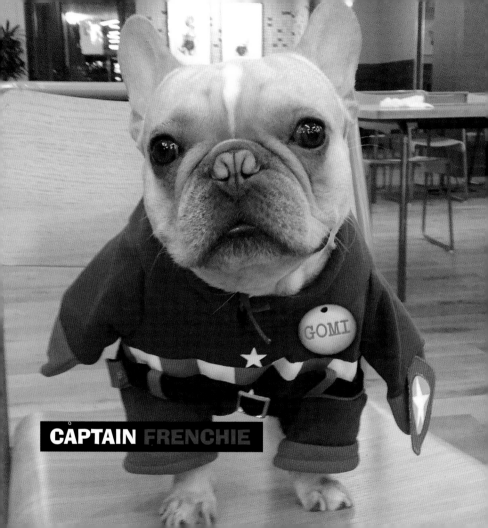

CAPTAIN FRENCHIE

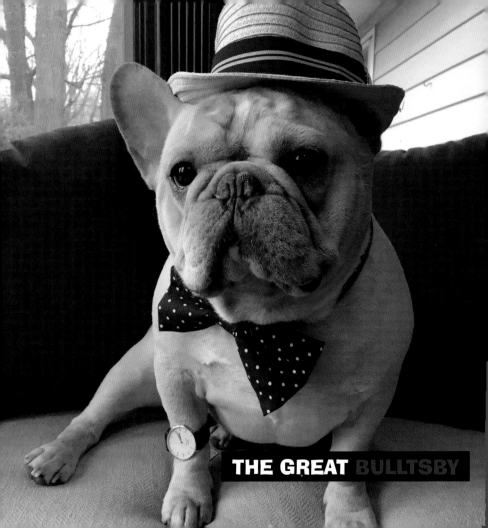

THE GREAT BULLTSBY

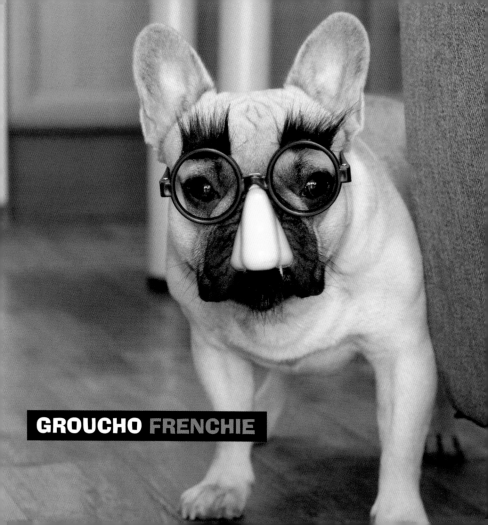

GROUCHO FRENCHIE

WILD

BULLIES

Frenchies in disguise

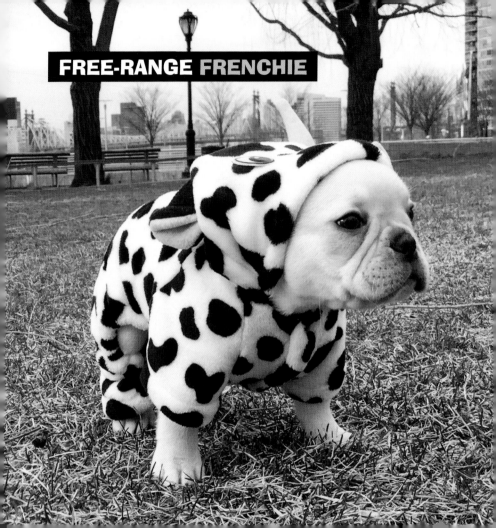

FREE-RANGE FRENCHIE

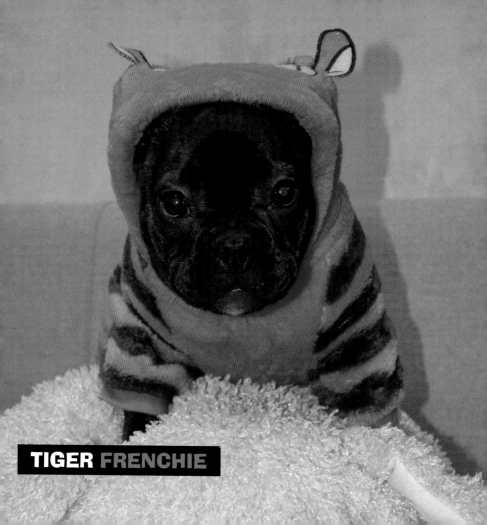

TIGER FRENCHIE

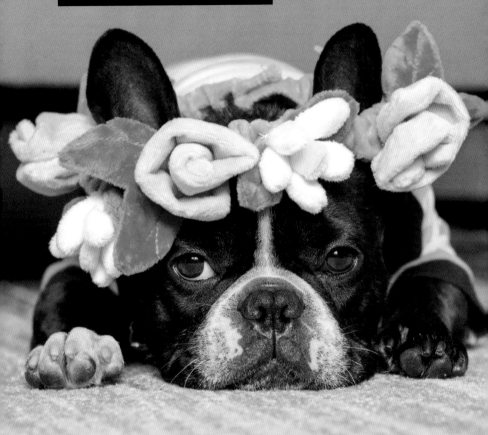

FLORAL FRENCHIE

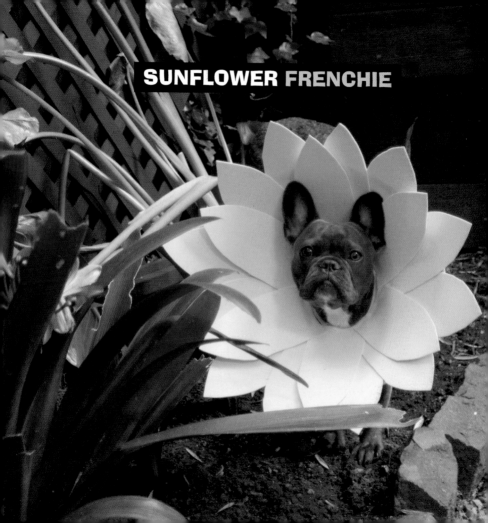

SUNFLOWER FRENCHIE

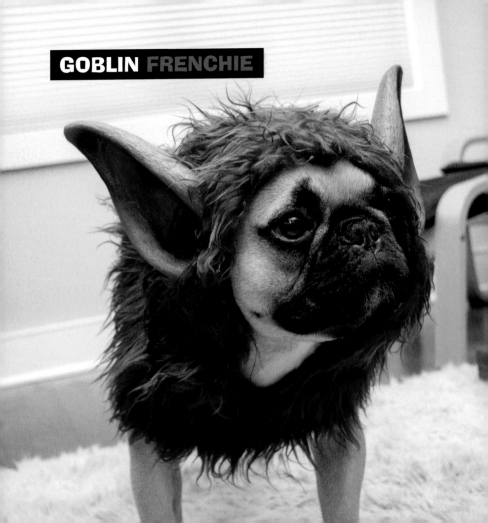

GOBLIN FRENCHIE

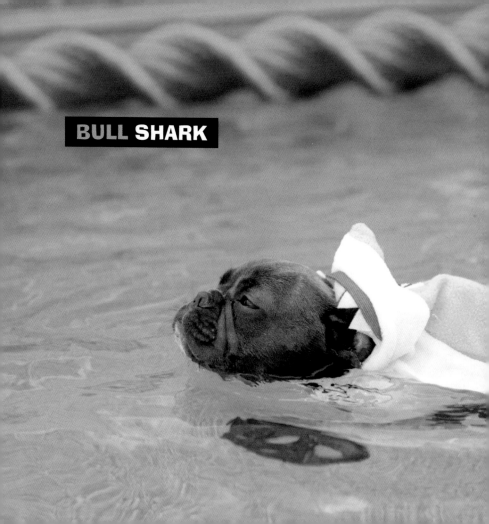

BULL SHARK

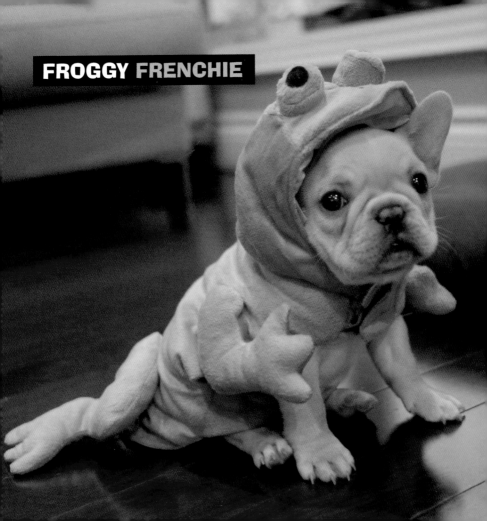

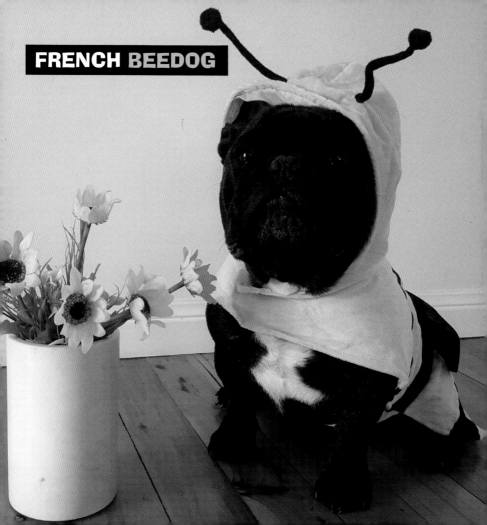

FRENCH BEEDOG

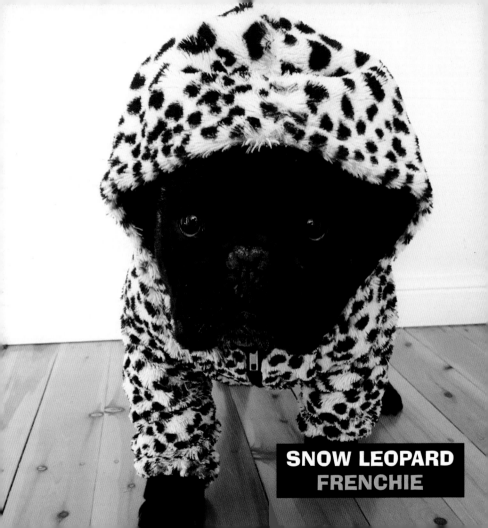

SNOW LEOPARD
FRENCHIE

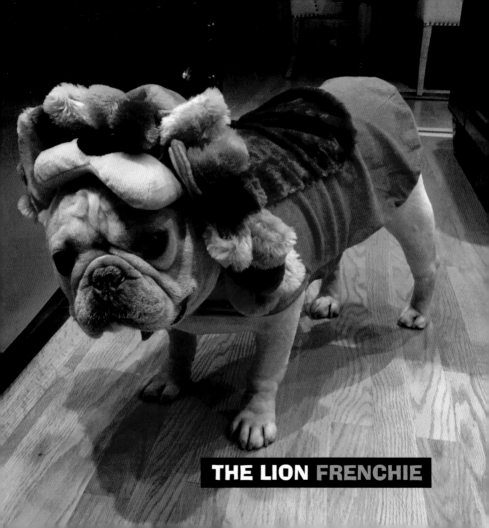

THE LION FRENCHIE

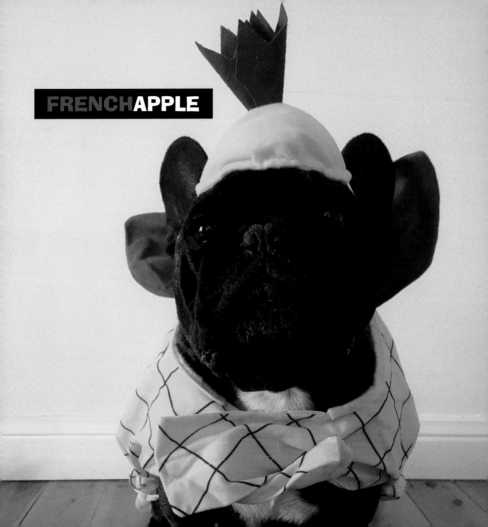

FRENCH**APPLE**

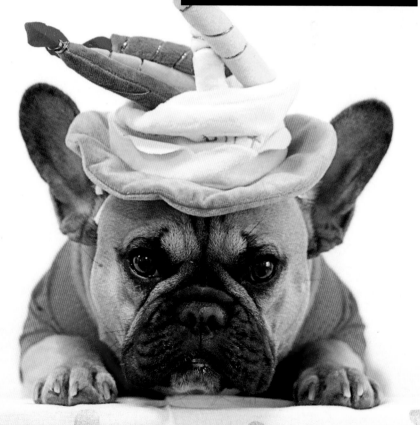

BIRTHDAY FRENCHIE

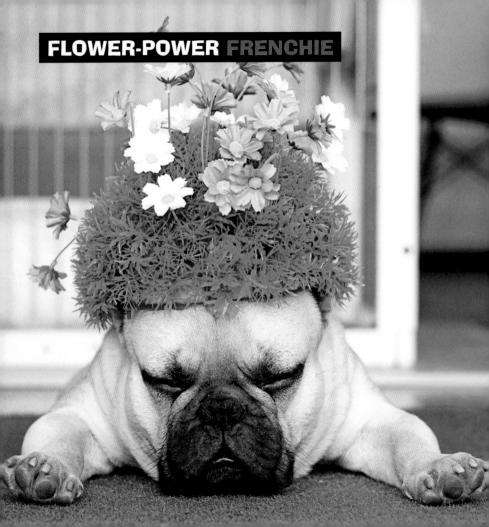

FLOWER-POWER FRENCHIE

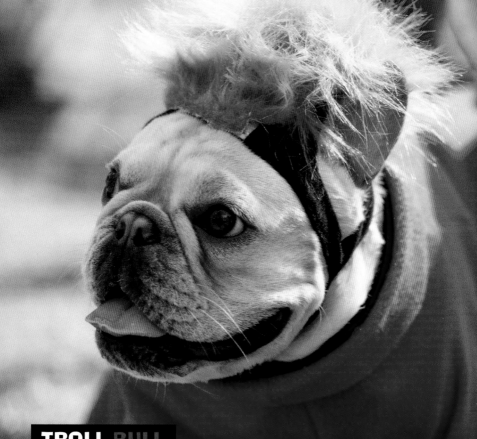

TROLL BULL

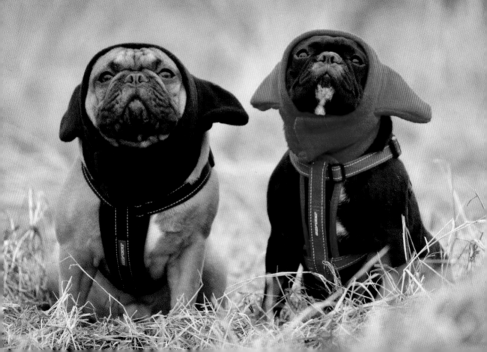

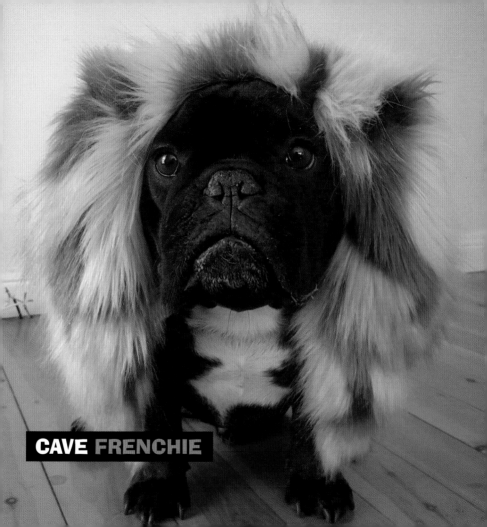

CAVE FRENCHIE

FESTIVE

FRENCHIES

Holiday the bulldog way!

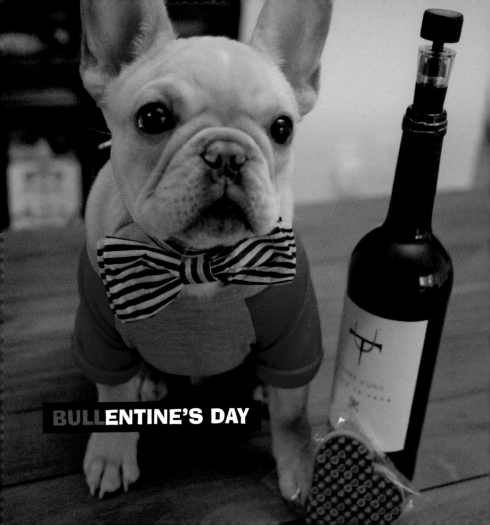

BULLENTINE'S DAY

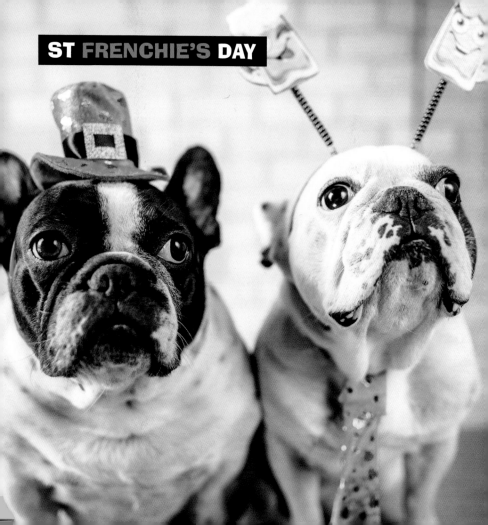

ST FRENCHIE'S DAY

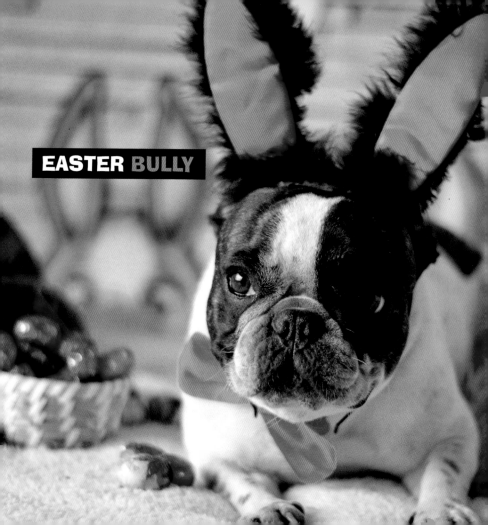

EASTER BULLY

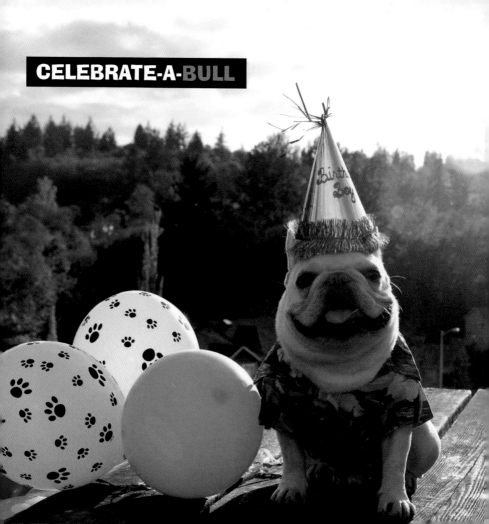

CELEBRATE-A-BULL

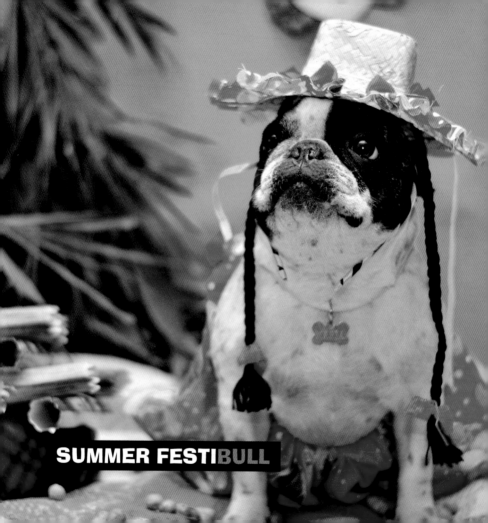

SUMMER FESTIBULL

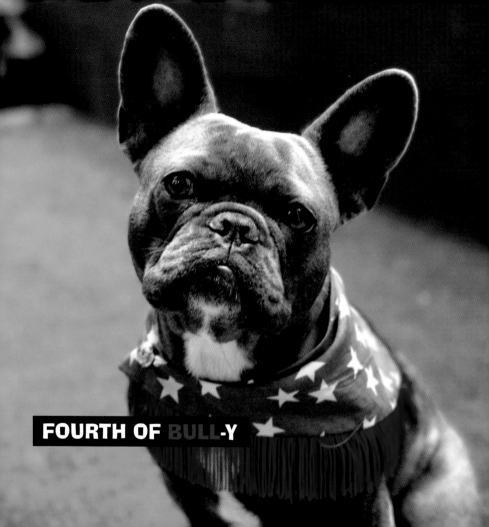

FOURTH OF BULL-Y

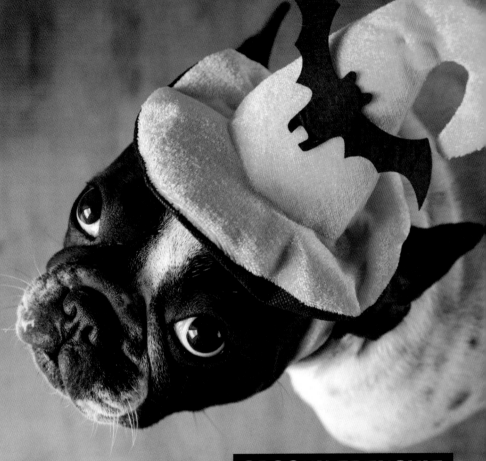

SPOOKY FRENCHIE

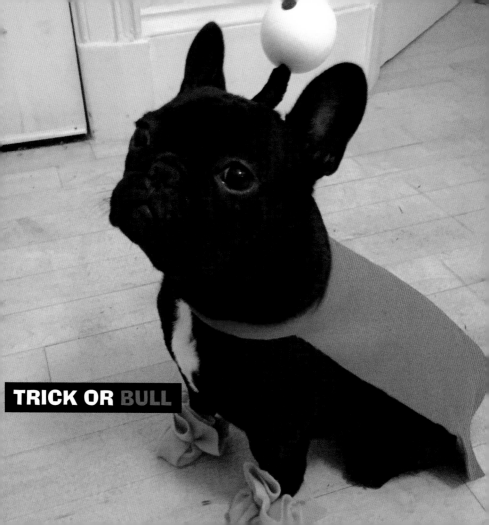

TRICK OR BULL

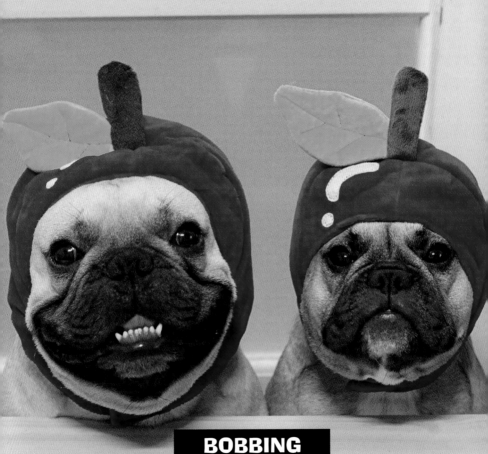

BOBBING
FOR BULLIES

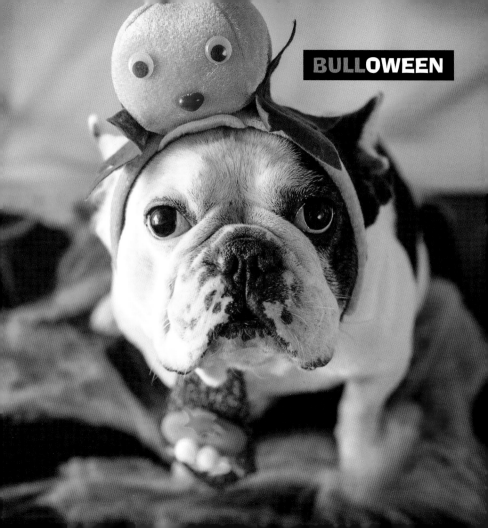

BULLOWEEN

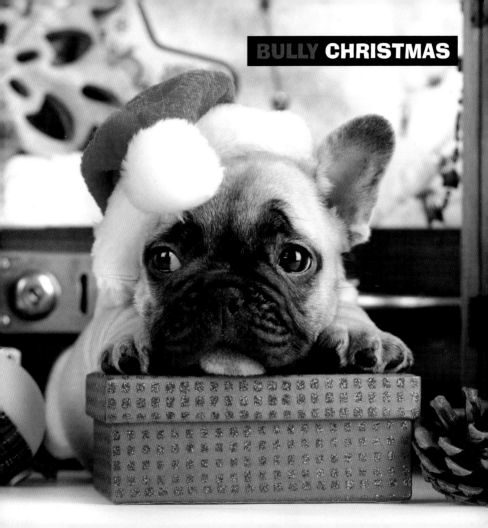

BULLY **CHRISTMAS**

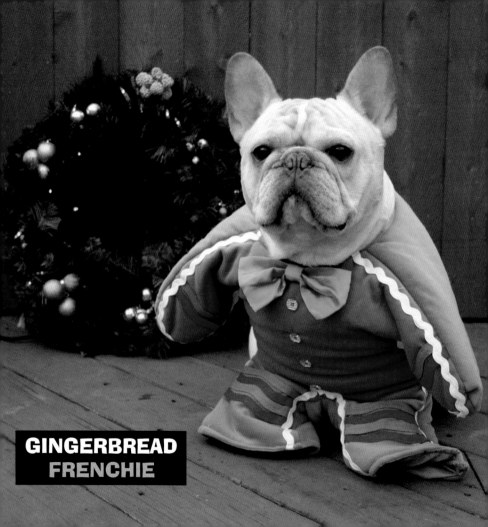

GINGERBREAD FRENCHIE

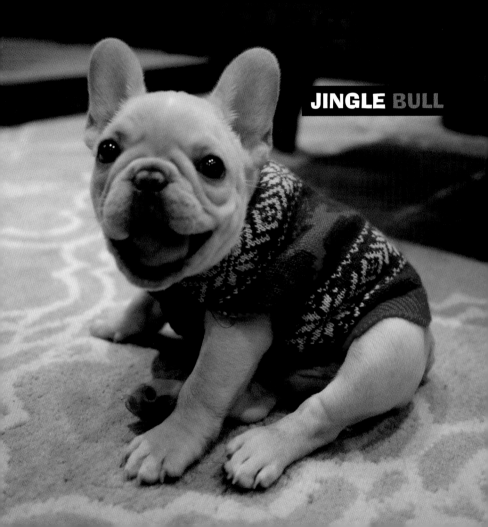

JINGLE BULL

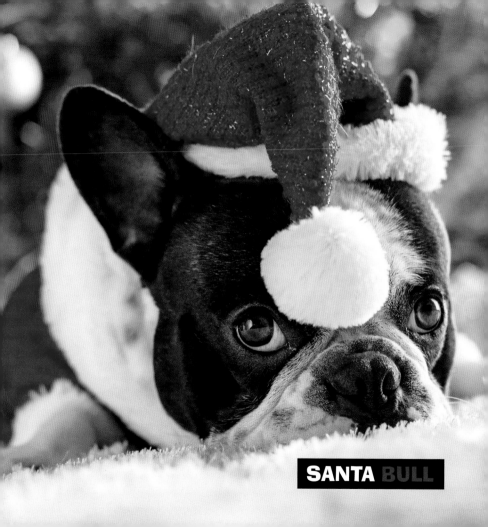

SANTA BULL

FRENCHIE

STYLE
Best-dressed bullies

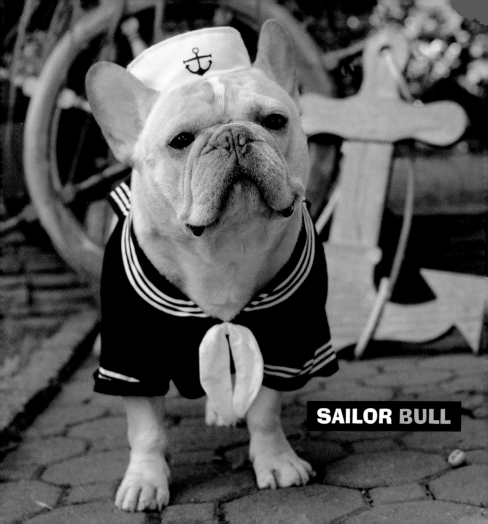

SAILOR BULL

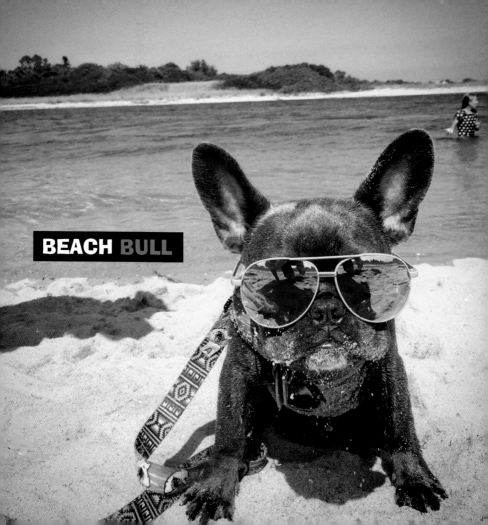

BEACH BULL

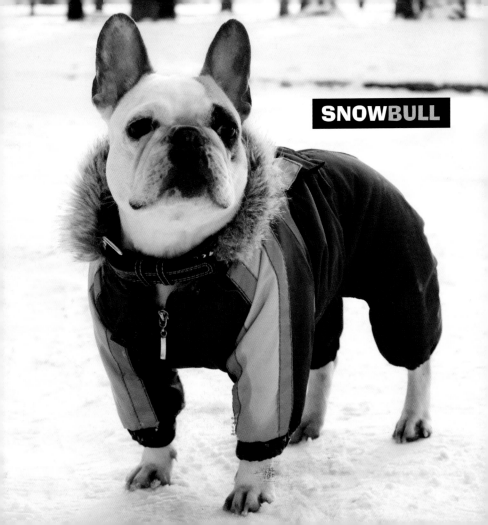

SNOWBULL

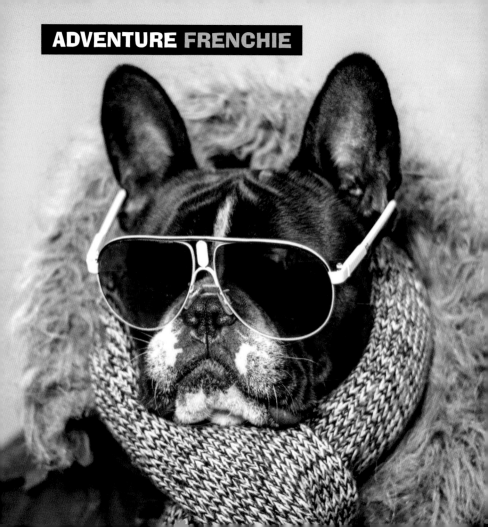

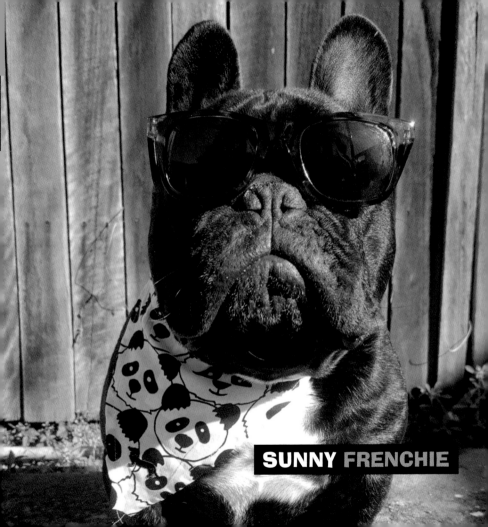

SUNNY FRENCHIE

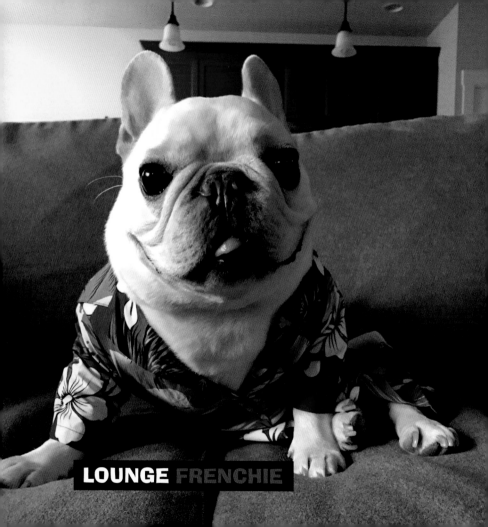

LOUNGE FRENCHIE

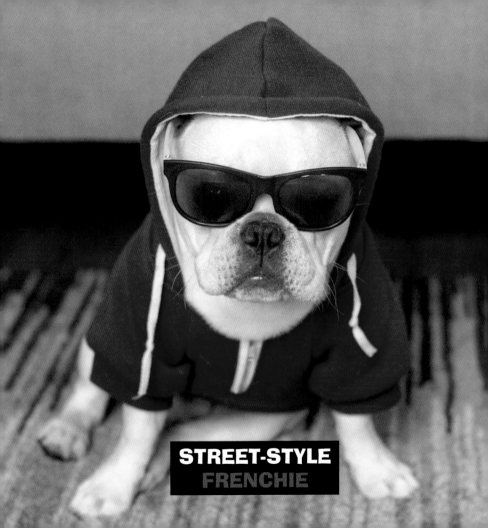

STREET-STYLE
FRENCHIE

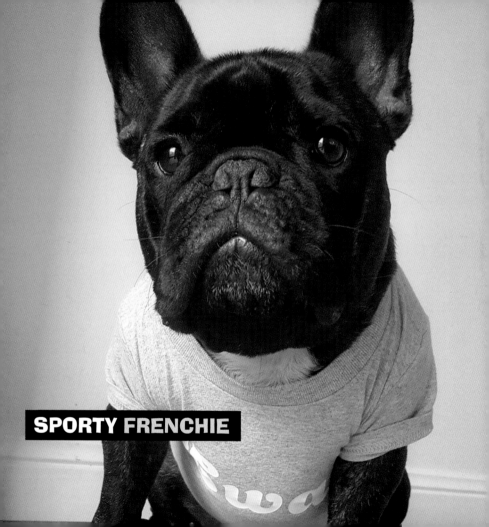

SPORTY FRENCHIE

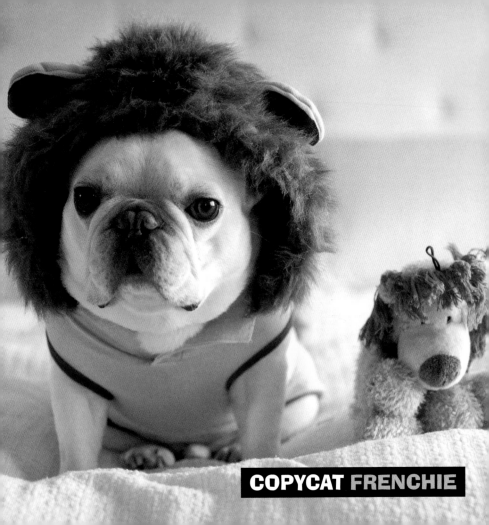

COPYCAT FRENCHIE

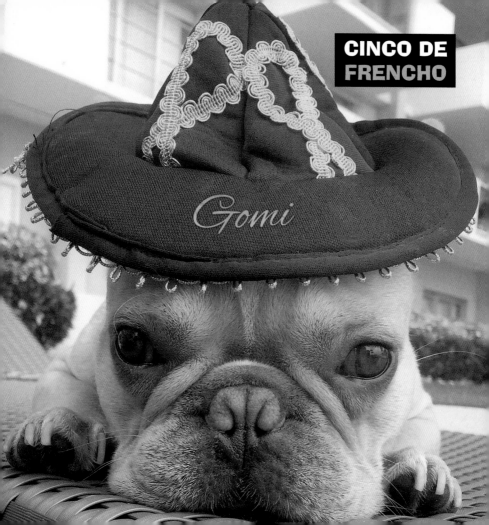

CINCO DE
FRENCHO

Gomi

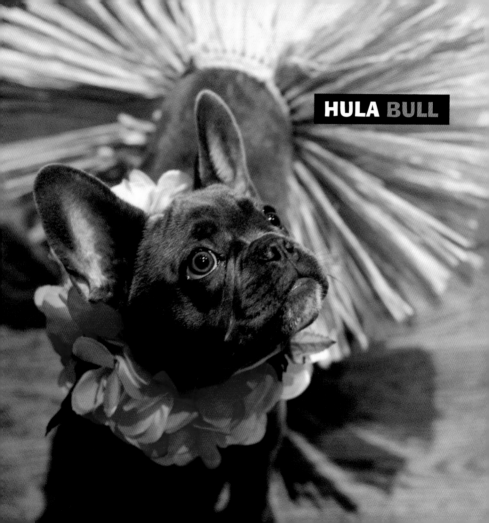

HULA BULL

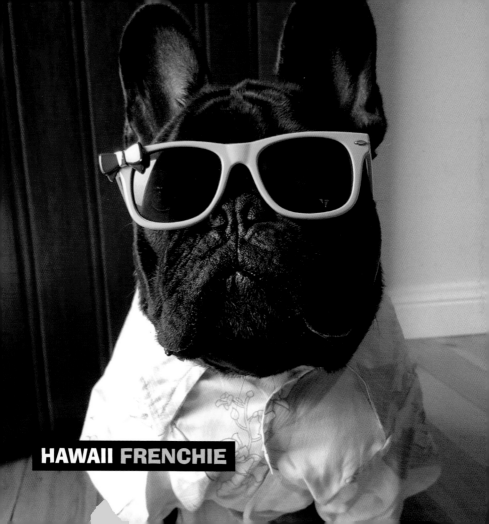

HAWAII FRENCHIE

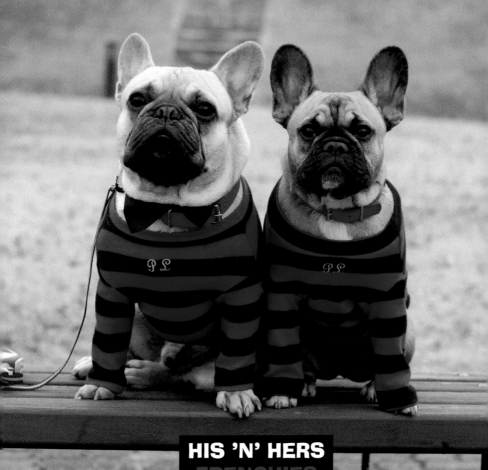

HIS 'N' HERS
FRENCHIES

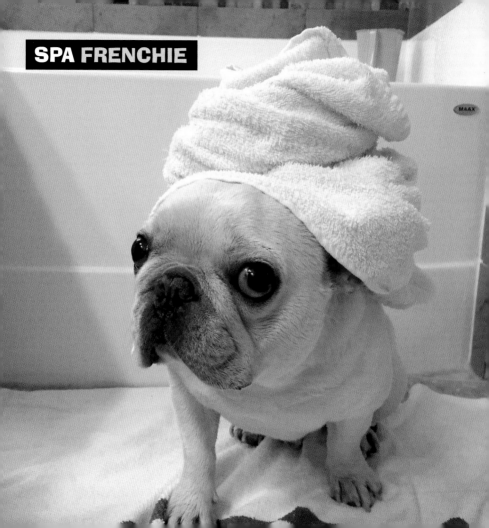

SPA FRENCHIE

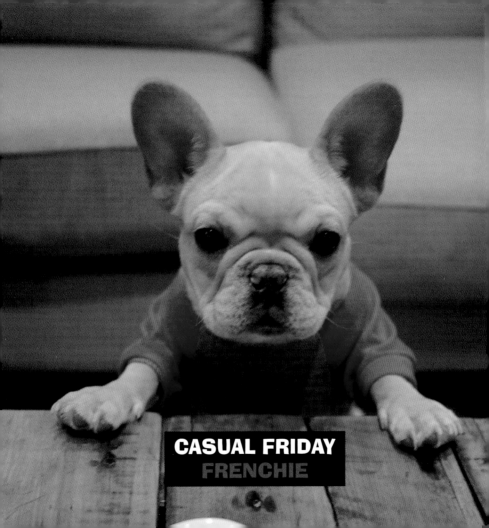

CASUAL FRIDAY
FRENCHIE

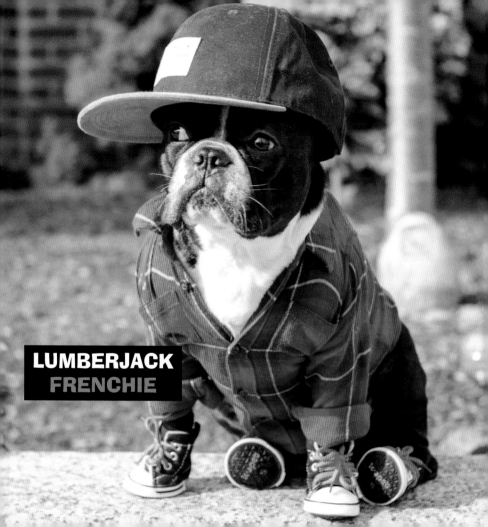

LUMBERJACK
FRENCHIE

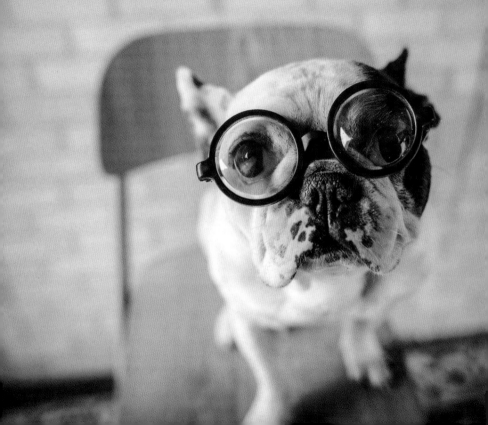

GEEK FRENCHIE

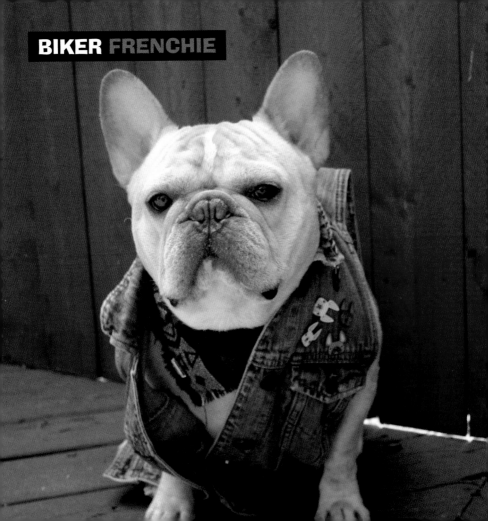

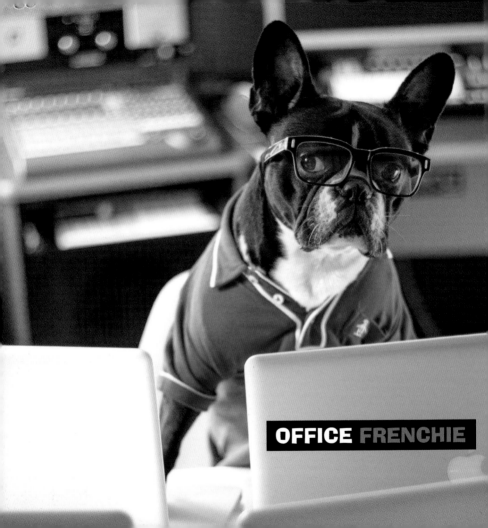

OFFICE FRENCHIE

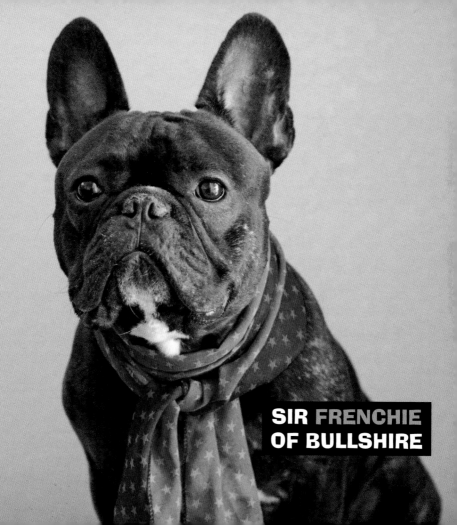

SIR FRENCHIE OF BULLSHIRE

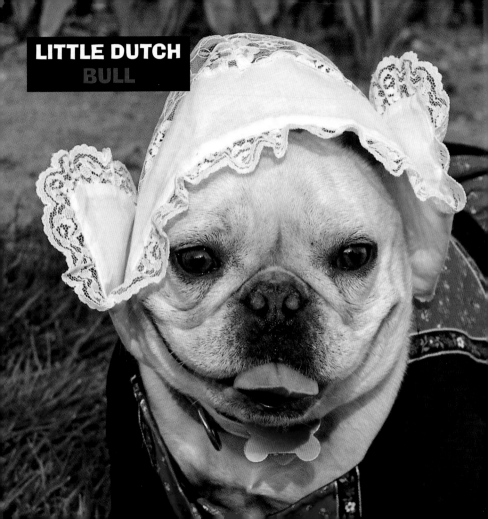

LITTLE DUTCH
BULL

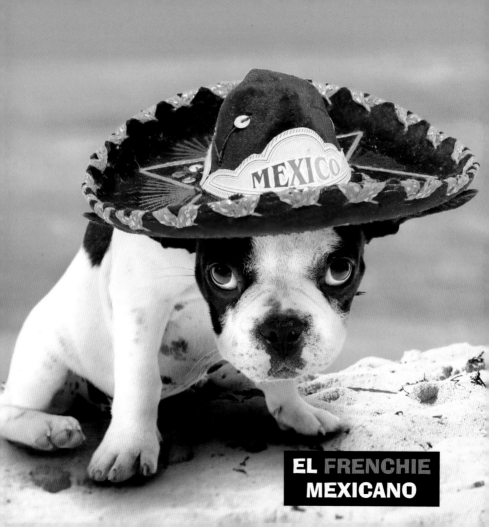

EL FRENCHIE
MEXICANO

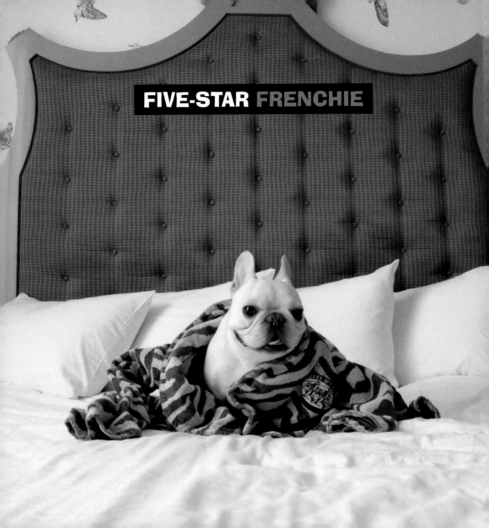

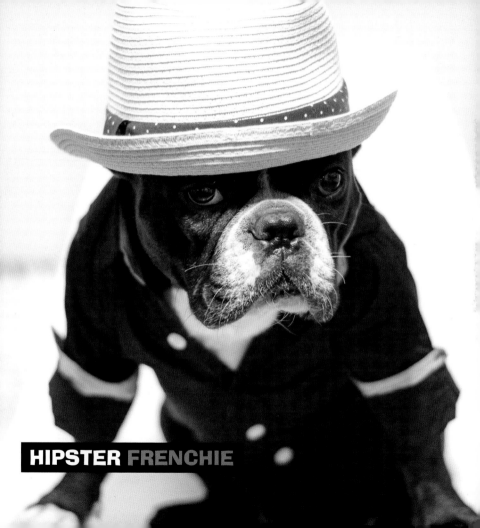

HIPSTER FRENCHIE

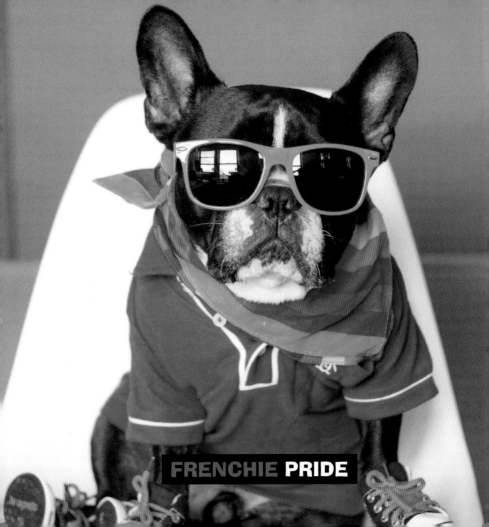

FRENCHIE **PRIDE**

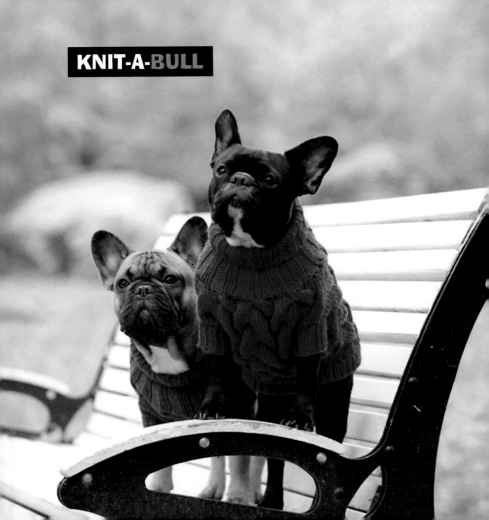

KNIT-A-BULL

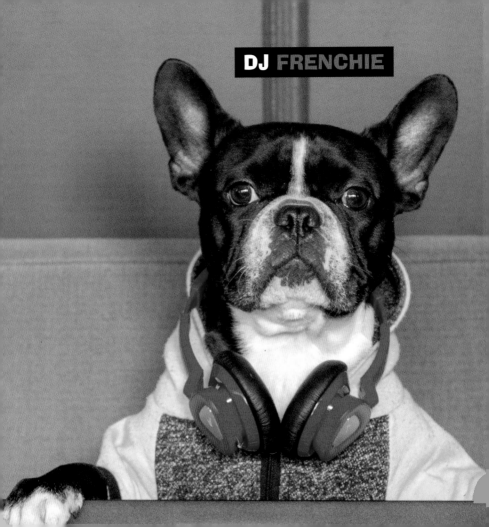

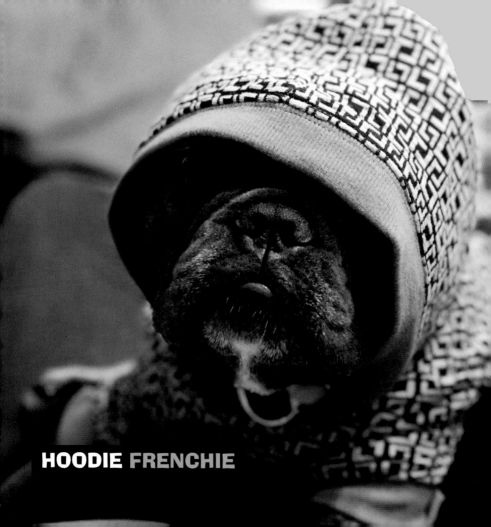

HOODIE FRENCHIE

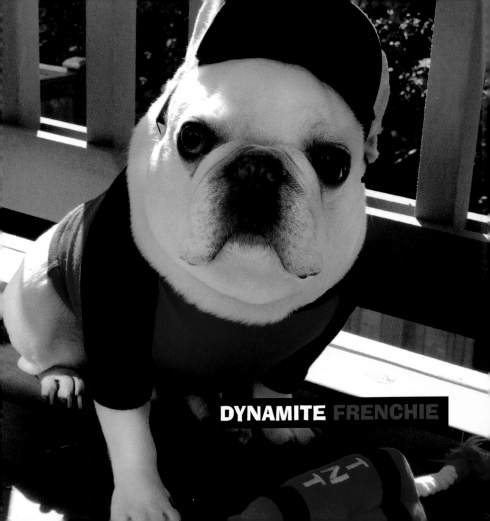

DYNAMITE FRENCHIE

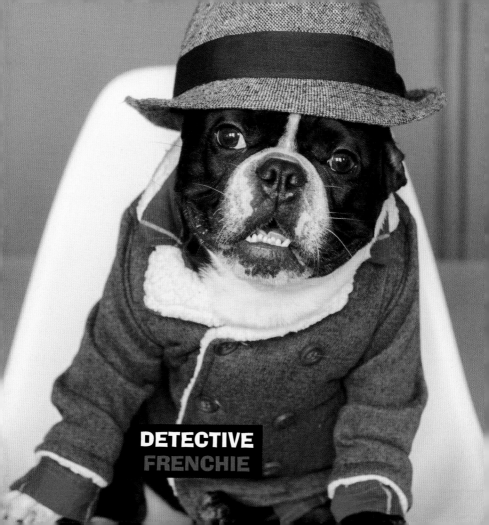

DETECTIVE
FRENCHIE

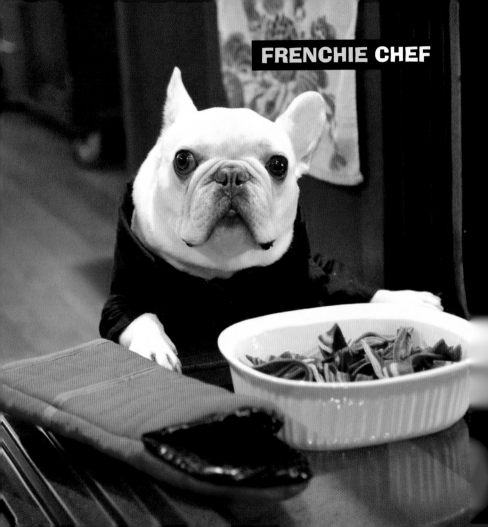

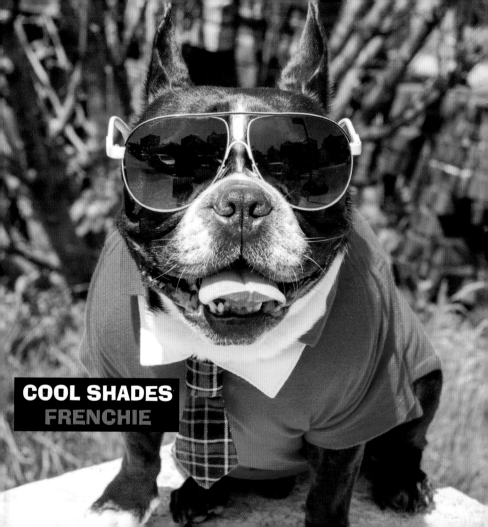

COOL SHADES
FRENCHIE

Picture Credits

BULLYWOOD

p.6 Batbull – Oscar the Frenchie – Instagram: @OscarFrenchieNYC
p.7 Superbull – Darcy D the French Bulldog – Instagram: @darcy_d_french_b
p.8 Dr Frenchie. – Lord Dudley – Boi Lan Ong – Instagram: @lord_dudley_the_frenchie
p.9 Frenchie PI – Jamie Kakleas – Romeo Oh Romeo – Instagram: @ohhhromeo
p.10 Frenchie Fonteyn – Darla – Rachel Santiago – Bebé Diva Wear
p.11 The Tin Frenchie – Instagram: @ryman.the.frenchie
p.12 Apprentice Frenchies – Oscar the Frenchie – Instagram: @OscarFrenchieNYC
p.13 Frenchie Berra – Jamie Kakleas – Romeo Oh Romeo – Instagram: @ohhhromeo
p.14 The Masked Frenchie – Lord Dudley – Boi Lan Ong – Instagram: @lord_dudley_the_frenchie
p.15 Frenchie Mouse – Adriana Herrera – Shutterstock
p16 Frenchie Phone Home – Leo Redbone – Instagram: @leo_redbone
p.17 Frenchie the Pooh – Jamie Kakleas – Romeo Oh Romeo – Instagram: @ohhhromeo
p.18 The Little Merbull – Jamie Kakleas – Romeo Oh Romeo – Instagram: @ohhhromeo
p.19 Snoop Frenchie – Oscar the Frenchie – Instagram: @OscarFrenchieNYC
p.20 Frenchie is the New Bull – Gomi The Frenchie – Instagram: @GomiTheFrenchie
p.21 Frenchie Monroe – Oscar the Frenchie – Instagram: @OscarFrenchieNYC
p.22 Downton Frenchie – Sir Charles Barkley – Instagram: @barkleysircharles
p.23 Fargo Frenchie – Jamie Kakleas – Romeo Oh Romeo – Instagram: @ohhhromeo
p.24 Sunset Bullyvard – Ellie – Portraits by Michael Stahl – www.portraitsbymichaelstahl.com
p.25 Captain Frenchie – Gomi The Frenchie – Instagram: @GomiTheFrenchie
p.26 The Great Bulltsby – Jamie Kakleas – Romeo Oh Romeo – Instagram: @ohhhromeo
p.27 Groucho Frenchie – Emma Wakelin – Instagram: @griffinfrenchie

WILD BULLIES

p.30 Free-range Frenchie – Charlie the Frenchie – Instagram: @IrresistibleCharlie
p.31 Tiger Frenchie – Viva_Viktoriia – Shutterstock
p.32 Floral Frenchie – Oscar the Frenchie – Instagram: @OscarFrenchieNYC
p.33 Sunflower Frenchie – Darcy D the French Bulldog, @darcy_d_french_b

p.34 Goblin Frenchie – Instagram: @ryman.the.frenchie
p.35 Bull Shark – Darcy D the French Bulldog, @darcy_d_french_b
p.36 Froggy Frenchie – Tofu the French Bulldog – Instagram: @tofuthefrenchbulldog
p.37 French Beedog – Lord Dudley – Boi Lan Ong – Instagram: @lord_dudley_the_frenchie
p.38 Snow Leopard Frenchie – Lord Dudley – Boi Lan Ong – Instagram: @lord_dudley_the_frenchie
p.39 The Lion Frenchie – Jamie Kakleas – Romeo Oh Romeo – Instagram: @ohhhromeo
p.40 Frenchapple – Lord Dudley – Boi Lan Ong – Instagram: @lord_dudley_the_frenchie
p.41 Birthday Frenchie – Emma Wakelin – Instagram: @griffinfrenchie
p.42 Flower-power Frenchie – Emma Wakelin – Instagram: @griffinfrenchie
p.43 Troll Bull – TerryJ – iStock
p.44 Explorer Frenchies – Lola and Pepe – Instagram: @lola_pepe_frenchies
p.45 Cavefrenchie – Lord Dudley – Boi Lan Ong – Instagram: @lord_dudley_the_frenchie

FESTIVE FRENCHIES

p.48 Bullentine's Day – Tofu the French Bulldog – Instagram: @tofuthefrenchbulldog
p.49 St Frenchie's Day – KikoStock – Shutterstock
p.50 Easter Bully – Nancy Ayumi Kunihiro – Shutterstock
p.51 Celebrate-a-Bull – Sir Charles Barkley – Instagram: @barkleysircharles
p.52 Summer Festibull – Nancy Ayumi Kunihiro – Shutterstock
p.53 Fourth of Bully – Darcy D the French Bulldog, @darcy_d_french_b
p.54 Spooky Frenchie – KikoStock – Shutterstock
p.55 Trick or Bull – Leo Redbone – Instagram: @leo_redbone
p.56 Bobbing for Bullies – Emma Wakelin – Instagram: @griffinfrenchie
p.57 Bulloween – KikoStock – Shutterstock
p.58 Bully Christmas – Liliya Kulianionak – Shutterstock
p.59 Gingerbread Frenchie – Jamie Kakleas – Romeo Oh Romeo – Instagram: @ohhhromeo
p.60 Jingle Bull – Tofu the French Bulldog – Instagram: @tofuthefrenchbulldog
p.61 Santa Bull – Patryk Kosmider – Shutterstock

FRENCHIE STYLE

p.64 Sailor Bull – Jamie Kakleas – Romeo Oh Romeo – Instagram: @ohhhromeo
p.65 Beach Bull – Darcy D the French Bulldog, @darcy_d_french_b
p.66 Snowbull – mala_koza – Shutterstock

p.67 Adventure Frenchie – Oscar the Frenchie – Instagram: @OscarFrenchieNYC
p.68 Sunny Frenchie – Lord Dudley – Boi Lan Ong – Instagram: @lord_dudley_the_frenchie
p.69 Lounge Frenchie – Sir Charles Barkley – Instagram: @barkleysircharles
p.70 Street-style Frenchie – Charlie the Frenchie – Instagram: @IrresistibleCharlie
p.71 Sporty Frenchie – Lord Dudley – Boi Lan Ong – Instagram: @lord_dudley_the_frenchie
p.72 Copycat Frenchie – Sir Charles Barkley – Instagram: @barkleysircharles
p.73 Cinco de Frenchie – Gomi The Frenchie – Instagram: @GomiTheFrenchie
p.74 Hula Bull – Darcy D the French Bulldog, @darcy_d_french_b
p.75 Hawaii Frenchie – Lord Dudley – Boi Lan Ong – Instagram: @lord_dudley_the_frenchie
p.76 His 'n' Hers Frenchies – Emma Wakelin – Instagram: @griffinfrenchie
p.77 Spa Frenchie – Sir Charles Barkley – Instagram: @barkleysircharles
p.78 Casual Friday Frenchie – Tofu the French Bulldog – Instagram: @tofuthefrenchbulldog
p.79 Lumberjack Frenchie – Oscar the Frenchie – Instagram: @OscarFrenchieNYC
p.80 Geek Frenchie – KikoStock – Shutterstock
p.81 Biker Frenchie – Jamie Kakleas – Romeo Oh Romeo – Instagram: @ohhhromeo
p.82 Office Frenchie – Oscar the Frenchie – Instagram: @OscarFrenchieNYC
p.83 Sir Frenchie of Bullshire – elvissa via VisualHunt / CC BY
p.84 Little Dutch Bull – liveslow – iStock
p.85 El Frenchie Mexicano – Patryk Kosmider – Shutterstock
p.86 Five-star Frenchie – Sir Charles Barkley – Instagram: @barkleysircharles
p.87 Hipster Frenchie – Oscar the Frenchie – Instagram: @OscarFrenchieNYC
p.88 Frenchie Pride – Oscar the Frenchie – Instagram: @OscarFrenchieNYC
p.89 Knit-a-bull – Lola and Pepe – Instagram: @lola_pepe_frenchies
p.90 DJ Frenchie – Oscar the Frenchie – Instagram: @OscarFrenchieNYC
p.91 Hoodie Frenchie – Darcy D the French Bulldog, @darcy_d_french_b
p.92 Dynamite Frenchie – Sir Charles Barkley – Instagram: @barkleysircharles
p.93 Detective Frenchie – Oscar the Frenchie – Instagram: @OscarFrenchieNYC
p.94 Frenchie Chef – Sir Charles Barkley – Instagram: @barkleysircharles
p.95 Cool Shades Frenchie – Oscar the Frenchie – Instagram: @OscarFrenchieNYC